IMAGES
of America

LITTLE HAVANA

ON THE COVER: Riverside Elementary School was the center of activity for many young denizens of the neighborhood. In this photograph, taken in May 1945, costumed students were preparing for a pageant, "I Hear America Singing," as part of the city of Miami's observance of "I Am An American Day," performed in the waning months of World War II. (Courtesy Jackie Biggane.)

IMAGES of America
LITTLE HAVANA

Paul S. George, Ph.D.

ARCADIA PUBLISHING

Copyright © 2006 by Paul S. George, Ph.D.
ISBN 0-7385-4345-4

Published by Arcadia Publishing
Charleston SC, Chicago IL, Portsmouth NH, San Francisco CA

Printed in the United States of America

Library of Congress Catalog Card Number: 2006935061

For all general information contact Arcadia Publishing at:
Telephone 843-853-2070
Fax 843-853-0044
E-mail sales@arcadiapublishing.com
For customer service and orders:
Toll-Free 1-888-313-2665

Visit us on the Internet at www.arcadiapublishing.com

To my parents, Alice and Sargis George, who raised us in Riverside, Shenandoah, and Little Havana, and our aunts, uncles, and grandmother, who were always there to help.

Contents

Acknowledgments		6
Introduction		7
1.	Pioneer Days	9
2.	The Rise of Riverside and Adjoining Neighborhoods	17
3.	The Booming Twenties, the Rise of Shenandoah, and Other nearby Neighborhoods	33
4.	Depression and Recovery	59
5.	War and Peace	83
6.	The Postwar Boom	93
7.	Little Havana	109

Acknowledgments

In the course of preparing this pictorial history, I relied on the help and goodwill of so many wonderful people. Many are recognized by their names following the images in the pages of this book. Others worked "behind the scenes" to help bring this work to fruition. They include Dr. Nora Hendrix; Norma Orovitz and the fine folks at the Miami Jewish Home and Hospital for the Aged; Marcia Zerivitz and Ana Rodriguez at the Jewish Museum of Florida; my "family" at the Historical Museum of Southern Florida, especially Dr. Mara Zapata; John and Mary Reed; Janis Barrett; Sahir Imam; Joe Wilkins; and my wonderful "real" family, Laura, Paul Jr., Matthew, and Maryrose. A special thanks are due Arva Parks, Larry Wiggins, and Dr. Bill Straight, who provided not only images for this work, but also wise counsel. Barbara Robbins, a wonderful photographer, worked with me patiently and unselfishly, as did my "IT" (information technology) guy, Giani Alaimo, a whiz with a computer. If I have left someone out, please forgive me.

INTRODUCTION

Miami's Little Havana has become well known over the past four decades as Florida's modern-day Ellis Island. Hundreds of thousands of refugees from Castro's Cuba and émigrés from Nicaragua, Honduras, Guatemala, and other Spanish-speaking countries in the hemisphere stopped first in this neighborhood, stretching from the Miami River west to Thirty-seventh Avenue and from another segment of the same stream south to U.S. Highway 1, as they made their way toward freedom and opportunity.

Before there was a Little Havana, there was a Riverside and a Shenandoah and adjacent neighborhoods. These were the old neighborhoods that used to be where Little Havana's most historic areas are now. Carved out of the pine woods at the beginning of the last century, Riverside acquired its name from its close proximity to the meandering Miami River, and because one of its subdivisions, created by prominent early landholder Mary Brickell, bore that name. A white middle-class suburb, Riverside was home to many prominent Miamians. It contained elegant, two-story frame homes and other simpler residences. Later newer homes bore the bungalow style of architecture. The real-estate boom of the mid-1920s led to plethora of masonry apartments, many with names above their entranceways.

A self-contained neighborhood, Riverside also claimed, by the mid-1920s, the area's largest elementary school, the county's first junior high school, hospitals, movie theaters, and a bustling retail area along its main arteries, including broad, beautiful West Flagler Street. Riverside was home to two of the city's most important recreational parks, several pioneer churches, and the Riverside Mercantile Building, which served as headquarters of the Ku Klux Klan. Even with its rapid development, Riverside's early character could be seen in the profusion of fruit groves dotting its landscape as late as the 1920s.

Lying immediately south of portions of Riverside, with Southwest Eighth Street the dividing line, stood Shenandoah, a residential community that emerged in the third decade of the 20th century. Several of its subdivisions bore the name of the beautiful valley lying between the Allegheny and Blue Ridge Mountains in Virginia, and so the whole community became known as Shenandoah. This quarter was characterized by attractive Mediterranean Revival–style homes, products of the boom. Another wave of construction commenced in the late 1930s as the Great Depression waned and better times returned, resulting in an attractive array of Streamline Moderne or art deco–style homes. Almost entirely residential, Shendandoah's retail sector stood primarily along Southwest Eighth Street and Coral Way.

The demographics of Riverside and Shenandoah changed dramatically in the Depression decade as increasing numbers of Jews moved south from the northeastern United States. Their businesses, professional offices, and institutions followed. The Jewish presence in both neighborhoods remained strong until the late 1950s, when another era of prosperity and population growth brought another construction boom to Miami. This boom prompted the migration of many residents of these older neighborhoods to new developments elsewhere in the county.

This urban exodus took place just as large numbers of Cubans, who were fleeing the political turbulence of their homeland, came to Miami. More than 30,000 Cuban refugees were residing in Dade County before Fidel Castro came to power in 1959, with many living in Riverside and Shenandoah. With the onset of the Castro regime, the beginnings of a huge influx of Cuban refugees into these neighborhoods would lead to their transformation into the area we know today as Little Havana.

Little Havana and Calle Ocho (Southwest Eighth Street), its main artery, bustle with a pedestrian life seen in few other places in Greater Miami. The human scale of its old structures, its glitzy restaurants with their surfeit of blinking lights and ubiquitous outdoor coffee counters, and the animated conversations of men and women (fueled with pungently sweet cups or "thimbles" of café) over the latest events and conditions in Cuba help set it apart.

With its many Spanish-speaking nationalities, Little Havana is anything but monochromatic. It is a quarter of political protests, marches, shrines and museums, and vendors selling produce and flowers. The quarter's parks are popular gathering places for *veijos*, or elderly men, who play dominoes, as well as for young mothers pushing little children in strollers. Little Havana is exotic, flamboyant, industrious, sometimes exasperating to the area's more staid "Anglo" residents, and ever evolving as new residents pour into America's "New Ellis Island" from countless countries in the Caribbean and Latin America.

One

PIONEER DAYS

Seminole Indians and Canoes on Miami River, Miami, Fla.

From the 1870s till the end of the 19th century, Native Americans, then identified only as Seminoles but known today as both Miccosukees (who live in the far reaches of Miami–Dade County and beyond) and Seminoles, poled down river in their hardy, dugout canoes bringing goods from the nearby Everglades to traders like William Brickell and James Girtman. The Native Americans brought alligator eggs, steaks, and skins; egret plumes; and coontie starch (used in baking and shoring up soups and stews) and exchanged these items for manufactured goods. This trade helped overcome decades of animosity and hostility between the races. (Courtesy Larry Wiggins.)

In the late 19th century, Miccosukees, who were involved in trade with the Brickells and others near the mouth of the Miami River, found a shoreline covered with subtropical trees. As late as the middle decades of the 20th century, the river's banks remained verdant. (Courtesy Larry Wiggins.)

Among the most prominent homesteaders in the future Little Havana were the Belchers, Sam and Jeanette, and their two young sons, Edwin and Harold. The Belchers arrived in 1891 after spending nine years in the Indian River communities of Cocoa and Titusville. They homesteaded 140 acres in an area bordered on the east by today's Southwest Seventeenth Avenue and on the west by Twenty-second Avenue. The land straddled today's Calle Ocho, thereby reaching into both future neighborhoods of Shenandoah and Riverside. Shown here are Sam and Jeanette Belcher. (Courtesy Lyn Esco.)

The Belcher homestead house, seen in the 1890s, sat near today's Southwest Seventeenth Avenue and Eighth Street. Other homesteaders farmed nearby areas, usually on 160-acre tracts of land. Most of the terrain was covered with Dade County pine trees, a durable wood employed by pioneer Miamians in the construction of their homes. (Courtesy Lyn Esco.)

Later the Belchers made a fortune as fuel distributors. Sam Belcher is pictured around 1920 in front of one of the company's huge oil drums near the entrance to the McArthur Causeway. The oil drums were Miami landmarks from the early 1900s until they were removed to make way for an expressway link with the causeway in the early 1970s. (Courtesy Lyn Esco.)

One of the earliest settlers in the Shenandoah area was Capt. Charles Josiah Rose, who arrived in Miami from Ohio in 1890. A Union army veteran, Rose homesteaded 160 acres of land around today's Coral Way and Southwest Twenty-second Avenue. In 1939, at age 95, Rose modeled for a statue of a Union soldier, which was executed for the Woodlawn Park Cemetery. In the same year, Captain Rose delivered the welcoming address to the 56th annual convention of the Grand Army of the Republic, which met in Miami. He died four years later. (Courtesy Barbara Robbins.)

Although the Brickell family did not live in today's Little Havana, it owned hundreds of acres of property comprising the quarter. The Brickells began purchasing land in the wilderness known as Miami or Fort Dallas soon after their arrival in the early 1870s. Three decades later, Mary Brickell, the family matriarch, named a subdivision she was developing west of the Miami River "Riverside." This became the neighborhood's name. The Brickell family (with the notable exception of Mary) is photographed in the early 1900s. (From the author's collection.)

Miami, Florida. Looking up Miami River from Musa Isle Landing.

The landing at Musa Isle attracted many boaters on the Miami River. Standing on the south side of the north fork of the Miami River east of today's Northwest Twenty-seventh Avenue Bridge, the landing's appearance indicated how primeval was the area on the perimeters of the city of Miami in the early 1900s. The Everglades stood but one-half mile from there. The city, which was still centered in downtown, was three miles east. (Courtesy Larry Wiggins.)

Grape Fruit from Richardson's Grove on Miami River, Fla.

A prominent early business in the area later known as Little Havana was Richardson's Groves, which stood near the site of the future Musa Isle Indian Village. Otis Richardson offered many items and services to his customers, including the shipment of crates of citrus to their home areas. (Courtesy Larry Wiggins.)

Two

THE RISE OF RIVERSIDE AND ADJOINING NEIGHBORHOODS

J. H. Tatum, who, along with his brothers, hailed from Cummings, Georgia, arrived in Miami in 1902 and quickly became involved in business in the young city. Soon he and his brothers were developing Riverside; later they created the subdivisions of Riverside Heights and Grove Park. The Tatums, who headed numerous developmental companies, were among the city's largest developers during the great real-estate boom of the 1920s. (Courtesy Historical Museum of Southern Florida.)

FREE! For The Entire Week

In order to give everybody an opportunity to see the coming aristocratic residence portion of the city of Miami we have instructed our bridge tender to allow all **Carriages, Hacks, Automobiles and Pedestrians** to cross our new 12th street bridge any time during this week free of charge. The street has been paved through to the General Lawrence road and the drive out that way is one of the best and most attractive anywhere about the city. Several lots are being cleared in Riverside preparatory to building houses and many lots have been sold to other parties who contemplate building during the summer. For a short time longer we will sell lots at the original price of **$300 for inside and $450 for corners**, on any street except Twelfth and those who buy now will be in on the ground floor. The work of paving other streets will be pushed along; city water and electric lights will be put in at once and everything possible will be done to make this the choicest portion of the city. **TOURISTS AND VISITORS ARE INVITED** to go over and have a look. Call at our office and get maps and information and free carriage if you like.

J. H. Tatum and Company, whose principals included the four Tatum brothers, was the primary developer of Riverside. In 1905, the company completed a toll bridge connecting the new neighborhood to the older downtown quarter. As this illustration indicates, the new bridge was toll free during one week in February 1905. (Courtesy Larry Wiggins.)

One of the jewels of the Riverside neighborhood was the old Warner House. Built in 1912 by J. W. Warner, who arrived in Miami in 1905 and worked as an auditor with the Florida East Coast Railway, this neoclassical antebellum structure served as a home for the Warner family. The Warners resided on the top two floors of the 22-room mansion above their Miami Floral Company. Now known as Warner Place, the building hosts a wide array of businesses and organizations. (Courtesy Larry Wiggins.)

Located on Southwest Eighth Street between Thirty-second Avenue and Thirty-fifth Avenues, Woodlawn Park Cemetery is the final resting place for more than 67,000 people. Opened in 1912 in the piney woods far beyond the city limits of Miami, the cemetery is comprised of numerous ethnic sections, a stunning mausoleum, and the final remains of many of the area's most important residents. The Victoria Lily pond shown here greets visitors to the cemetery. (Courtesy Larry Wiggins.)

At the time of its opening in 1912, Woodlawn Park Cemetery was served by a rudimentary road known as Orange Glade Road since orange groves looked out over it, while the Everglades were just a few miles northwest. Woodlawn Park became one of the area's largest, most important cemeteries, while Orange Glade Road evolved into the bustling Tamiami Trail, part of which is today's famed Calle Ocho. (Courtesy Larry Wiggins.)

For a short time in the early 1900s, a train brought the curious into the Everglades from its eastern edge, which stood as far east as the western edges of today's Little Havana. The Everglades Railway, as it was known, consisted initially of three railway cars pulled by a powerful African American known simply as "George." Later the system was reduced to one car pulled by a mule. The railway took guests to a large house with an observatory room to view the mysterious Everglades lying to the west. (Courtesy Historical Museum of Southern Florida.)

Biscayne Engineering, one of Miami's oldest businesses, began operating as a surveying and engineering company in 1898. Until 1979, when it moved its offices to East Little Havana, Biscayne Engineering was located in downtown Miami. The firm's staff posed for this photograph in 1915. The principals were J. J. Bennett, W. W. Shields, and W. E. Brown. (Courtesy George Bolton, Biscayne Engineering.)

Riverside Elementary School opened in 1914 to address the educational needs of youths in the rapidly growing neighborhood by that name. By the mid-1920s, with tens of thousands of new people in the city as a result of the land boom, Riverside became one of the largest elementary schools in the state of Florida. This photograph, taken c. 1918, is one of the earliest extant pictures. (From the author's collection.)

Miami Senior High School represents the first county high school in a school system that presently is the nation's fourth largest with more than 350,000 students. This photograph, taken in 1916, represents virtually all of the high school graduates of that year. Youths from Riverside and elsewhere in the city and county traveled to downtown Miami to attend the school. In 1928, Miami Senior High moved into a stunning new complex on the western edges of Riverside, well within the borders of today's Little Havana (From the author's collection.)

Plan of Glen Royal

Glen Royal was an ambitious subdivision standing outside of the Miami city limits. Created in 1915, it stretched from today's West Flagler Street to Northwest Third Street and from Twenty-second to Twenty-seventh Avenues. The development's main street was the Glen Royal Parkway, with its tree-laden medium in the center, moving diagonally in a northwest direction from the eastern border of the subdivision. Today a tall condominium complex stands at the eastern edge of the parkway. (Courtesy Larry Wiggins.)

This Sanborn insurance map of the early 1920s explains the geographic and cultural dimensions of South Miami, the black Bahamian settlement on the edge of Riverside. As seen here, the neighborhood contained a public school, Baptist and Methodist churches, a Sunday school, and numerous wood-frame homes, many built in the shotgun style. Today the neighborhood is heavily Hispanic. (Courtesy Larry Wiggins.)

Shotgun houses at 826 and 832 Southwest Fifth Avenue are rooted in the early Bahamian black community of South Miami. Composed of durable Dade County pine, shotgun houses feature open porches raised on blocks and an asymmetrical entranceway leading into a long hallway, from which every room is entered. According to lore, the style's name was derived from the fact that one could shoot a gun from the front door through the back without hitting anyone. (Courtesy Barbara Robbins.)

The Miami River comprises both the eastern and northern borders of Riverside/Little Havana. A working river, the stream today represents the fourth busiest port in the state of Florida with $4 billion in annual trade. The Miami River also provides an element of beauty for those early subdivisions and neighborhoods abutting it as it turns in an east-west direction beyond downtown Miami, comprising Little Havana's northern border. (Courtesy Larry Wiggins.)

Westmoreland, sometimes referred to as Westmoreland Park, was one of the first developments south of today's Southwest Eighth Street. As Shenandoah developed, Westmoreland became its eastern flank. F. C. Brossier and Son marketed this beautiful subdivision carved out of a Dade County pine forest. The development lies in the heart of today's Little Havana and was one of the first neighborhoods to host large numbers of Cuban refugees, first during the Batista dictatorship of the 1950s and next following the Castro takeover of Cuba's government in 1959. (From the author's collection.)

25

Observation Tower and Skating Rink, Car-dale, Miami, Fla.

The Cardale Tower was a popular element of the Cardale Resort on the north fork of the Miami River just east of today's Northwest Twenty-seventh Avenue. The area was called Musa Isle; "Musa" is a Native American word for banana. Opened in 1912, the resort featured a skating rink and a dance floor in a building shaped like a Quonset hut. The tower, which stood about 90 feet tall at the edge of the river, offered a spectacular view of the nearby Everglades. (Courtesy Larry Wiggins.)

One of the most stunning photographs of man's transformation of the Everglades is this picture taken from the Cardale Tower looming above the North Fork of the Miami River (on the left side of the photograph) near today's Northwest Twenty-seventh Avenue. Note the difference between the high ground in the bottom two-thirds of the photograph and the Everglades above. On the right is the Miami Canal, built between 1909 and 1913. This drainage canal reached as far north as Lake Okeechobee. (Courtesy Larry Wiggins.)

Founded in 1914 by Henry Coppinger Sr., a onetime groundskeeper at the magnificent Royal Palm Hotel in downtown Miami, Coppinger's Tropical Gardens was known by different names in a 50-year history that featured beautiful gardens and Native Americans who lived on the grounds in a "Seminole Village." Their village included chickee hut homes. They cooked over open fires, sewed, and posed for tourists. Later known as Pirates Cove, the attraction was a highly successful tourist draw. Coppinger's sons, Henry Jr. and George, seen in this photograph, won fame as alligator wrestlers

COPPINGER'S TROPICALAND AND INDIAN VILLAGE — Florida's oldest and picturesque Tropical Gardens —Alligator Farm. Entrance: N. W. 7th Street and 19th Ave., Miami, Florida—2 blocks west of Orange Bowl

Henry Coppinger opened Coppinger's Tropical Gardens on the south bank of the Miami River near Northwest Nineteenth Avenue in 1914. This popular tourist attraction offered alligator wrestling and beautiful gardens. Miccosukees lived on site and were items of curiosity for the many tourists who visited the attraction. During its lengthy period of operation, Coppinger's possessed different names and appearances. It closed in the 1960s. (Courtesy Larry Wiggins.)

The Musa Isle Indian Village, which opened in 1919, was the most famous of the numerous villages that attracted large numbers of tourists during the first half of the 20th century. Located on the south bank of the north fork of the Miami River near Northwest Twenty-seventh Avenue, the attraction operated until the 1960s. Its most popular offerings involved Miccosukees grouped together with Seminoles, who were also Creek Indians, and known by that name. They lived on the grounds of the attraction, wrestling alligators. (Courtesy Historical Museum of Southern Florida.)

Miami, Florida. Up the Miami River, Excursion Boat, "Sallie".

From the early 1900s until the era following World War II, excursions on the Miami River were a favorite activity for visitors. The *Sallie* was the most popular of the vessels taking tourists upriver and along its north fork to the edge of the Everglades. In the second photograph, tall mangrove trees are standing on water's edge. (Courtesy Larry Wiggins.)

THE EXCURSION BOAT "SALLIE" ON THE EVERGLADE TRIP, MIAMI, FLA.

The "Bambino"—Babe Ruth—is pictured at Miami Field, a baseball diamond that hosted many major-league spring training games. Opened in 1916 as Tatum Field, the facility was named for the Tatum brothers, who were major developers in early Miami and who owned large tracts of Riverside land. The complex stood immediately southwest of today's Orange Bowl Stadium. Renamed Miami Field, it was, for many years, Miami's premier baseball stadium. In 1920, Babe Ruth and the New York Yankees played two exhibition games against the Cincinnati Reds at Tatum Field. The Bambino got just one hit in six appearances at the plate. In 1964, the fabled field disappeared when it was replaced by new parking lots for the expanding Orange Bowl, which loomed above the outfield. (Courtesy Historical Museum of Southern Florida.)

Before he launched Coral Gables, George E. Merrick had already created 12 subdivisions, the last being the Twelfth Street Manors in 1921. It stood between West Flagler and Northwest Fifth Street on the north and Thirty-first to Thirty-seventh Avenues in an east-west direction. Doc Dammers, later Merrick's chief salesman in Coral Gables as well as that community's first mayor, was the auctioneer for the Twelfth Street Manors. (Courtesy Historical Museum of Southern Florida.)

This group of worshippers, primarily Bahamians, gather for a photograph in the early 1930s in front of the Seventh Street Gospel Hall, their new church on Southwest Seventh Street. Later the building and congregation were known as the Bible Truth Hall. (Courtesy Mayra Beers.)

Three
THE BOOMING TWENTIES, THE RISE OF SHENANDOAH, AND OTHER NEARBY NEIGHBORHOODS

A rare c. 1923 photograph shows the recently completed Tamiami Methodist Church with Southwest Eighth Street still an unimproved road. In subsequent years, the first substantial buildings would rise on the street, which was widened and paved as it became an integral part of the Tamiami Trail. Initially, Tamiami Methodist Church was a Deep South congregation. Today it is a Hispanic church. (Courtesy Arva Parks.)

The Miami River Inn is the city's premier bed-and-breakfast complex. It includes five Dade County pine buildings nearly one century old sitting just west of the Miami River. The inn's flagship building is the former Rose Arms Apartments, once popular with Midwest visitors. The apartment building is seen standing a block off the river behind an Australian pine in this early 1920s photograph, which also indicates a high level of activity on the river by members of the Miami Canoe Club. (Courtesy Florida State Archives.)

Members of the downtown Trinity Methodist Episcopal Church organized the Riverside Methodist Church at a service in Riverside Elementary School. The present complex, located at 985 Northwest First Street, was built in the 1920s and 1930s. The church was among the first to accommodate a wave of Castro-era Cuban refugees entering Miami. From left to right in this 1979 photograph are Paul Rosselle, a longtime lay leader of the congregation, Raymond Diaz, Evelynn Hallman, and Marilynn Hallman. (Courtesy Marilynn Hallman.)

One of Riverside's early churches, Calvary Baptist began as a mission church in 1922 in a tent near Southwest Seventeenth Avenue and Third Street. The imposing church of today was completed in 1925. With the influx of Cuban refugees to Miami following the Castro takeover of Cuba in 1959, Calvary Baptist became one of the first churches to offer services in Spanish. In 1967, the congregation became the first of Little Havana's early churches to conduct services entirely in Spanish. (Courtesy Arva Parks.)

The Seventh Day Adventist Temple is a textbook example of Mission-style architecture, which was prevalent among 18th-century Spanish mission churches in Mexico, southern Texas, and California. The temple was built by the Seventh Day Adventists, a congregation active in community affairs, in the mid-1920s. Today the Nicaraguan congregation occupying the church remains a vibrant presence in the old Riverside neighborhood. (Courtesy Larry Wiggins.)

Organized on New Year's Eve 1924, the St. Matthew Lutheran Church built a beautiful house of worship soon after at 135 Southwest Sixth Avenue. Like other nearby churches, the institution fit seamlessly into a residential block. A member of the Missouri Synod, the church remained at this location until after World War II, when it moved less than two miles west to 621 Beacon Boulevard. With a school and daycare center, St. Matthew's Evangelical Lutheran Church remains an important institution in Little Havana. (Courtesy Larry Wiggins.)

Miami's Roads neighborhood stands on the southern edge of the Little Havana area. Originally part of the Polly Lewis Donation, it became property of the Brickell family in the late 1800s. In the early 1920s, Mary Brickell began to sell and plan for the development of large portions of the wooded tract. A land auction in 1923 for the Brickell Hammock subdivision of the Roads drew a large crowd in to the intersection of today's Southwest Twenty-fifth Road and Second Avenue. (Courtesy Florida State Archives.)

In this early-1920s photograph, workers have begun clearing a wooded area for construction of the future Brickell Hammock subdivision of the Miami Roads neighborhood in the southern sector of today's Little Havana. Formerly the area was covered with Dade County pine trees. The term "Roads" emanates from its street names, which are wide and positioned on a slight diagonal. Comprised of three large subdivisions, the Roads has remained an upscale neighborhood since its inception. (Courtesy Florida State Archives.)

Max Orovitz was one of Greater Miami's most accomplished, influential Jewish leaders. Hailing from tiny Pelham, Georgia, Orovitz came to Miami with a newly minted law degree in 1925, "like all the Georgia crackers, to take a look at the land boom," as written by the same author in *Visions, Accomplishments, and Challenges: Mount Sinai Medical Center of Greater Miami, 1949–1984*. Successful in many business endeavors, he lived in the Shenandoah with his family for many years. Both of the art deco–styled homes the Orovitz family resided in remain in mint condition. Orovitz's civic and charitable activities included his lengthy tenure as president and later chairman of the board of trustees of Mount Sinai Medical Center. (Courtesy Mount Sinai Medical Center.)

Shenandoah was farmland and piney woods until the real-estate boom of the 1920s, when one residential subdivision after another bearing the name "Shenandoah" as part of its title appeared. Many spectacular homes designed in the Mediterranean Revival style arose, including that of William A. Hill, seen here. Hill was president of Hill Motor Car Company, which sold Essex and Hudson automobiles from its showrooms in Riverside. Hill's beautiful home stands at 1799 West Eleventh Street. (Courtesy Barbara Robbins.)

One of Riverside's most lavish homes was that of J. R. Tatum, a member of the prominent family of developers who were primarily responsible for the development of Riverside. Their Lawrence Estates subdivision comprised a large portion of the neighborhood. The Tatum home, with its signature gabled roof, stood on West Flagler Street near Northwest Fifteenth Avenue. (Courtesy Arva Parks.)

Many apartment houses arose in the Riverside and Shenandoah neighborhoods. Unlike the wide-scale demolition of homes in the Riverside area in recent decades, many older apartments are still standing in a neighborhood among the most densely populated in the state of Florida, where the demand for housing accommodations remains strong. The Sylvania Hotel, a product of the mid-1920s, sits at 226 Southwest Fifth Avenue and continues to operate at capacity. (Courtesy Larry Wiggins.)

The Dorn Hotel Apartments, completed in 1924, sat on the west bank of the Miami River on the edge of Riverside. The accommodation included a bar and restaurant and was said to have attracted many prominent guests, including Bob Hope. The riverfront in the area of the Dorn Hotel remained active into the early post–World War II era, when it became the Riverview Hotel, before entering a lengthy period of decline. The building was destroyed by fire in 1983. (Courtesy Larry Wiggins.)

Built in the beautiful Mediterranean Revival style of architecture in the mid-1920s, the Andes Apartments was one of many beautiful apartment houses in Riverside. In the 1920s and 1930s, a trolley car ran in front of it on Southwest Sixth Street. The building still stands, but the renovations to it have defaced it. (Courtesy Larry Wiggins.)

41

Constructed by Burdine's Department Store, the city's premier emporium, for its employees during the expansive real-estate boom of the mid-1920s, the Golden Arms Apartments later served regular renters. Located at 2000–2002 Southwest Twenty-fourth Street, the Golden Arms was one of the largest buildings in the Shenandoah neighborhood and offered guest courts for shuffleboard, a game very popular among locals and tourists, in the early decades of its operation. (Courtesy Larry Wiggins.)

The proud city of Coral Gables, planned and developed by George E. Merrick, operated a trolley line beginning in 1925, the year the municipality was incorporated. Trolleys followed two routes, one that proceeded east along West Flagler Street through Riverside into downtown Miami. The other line ran east on Coral Way through Shenandoah and into downtown. The Coral Gables trolley operated along Flagler Street till 1928, but it continued to run along Coral Way until the mid-1930s. (Courtesy Larry Wiggins.)

The first intensive development of Southwest Eighth Street (the Tamiami Trail) got underway in the 1920s. This large apartment building with retail stores on the bottom floor was a product of the great real-estate boom of the 1920s. Today it is home to several artists. (Courtesy Ideal Gladstone.)

Riverside's close proximity to downtown Miami made it an attractive venue for hotels and rooming houses serving the hordes of visitors flocking to Miami. The Mark Twain Hotel opened in the mid-1920s at 245 Southwest Sixth Avenue. Like many of the early Riverside hotels, the Mark Twain later became an apartment complex in a neighborhood with a dense population. (Courtesy Larry Wiggins.)

Standing at 701–711 Northwest First Street, the Edgar Poe Apartments offered corner apartments with large airy rooms, including a four-window bedroom. Renters and tourists alike occupied its commodious apartments. The Edgar Poe Apartments was a worthy representation of the fine housing stock in this portion of Riverside. (Courtesy Larry Wiggins.)

One of Little Havana's most important icons is the Tower Theater at 1508 Southwest Eighth Street. Opened in 1926, the theater was purchased in 1931 by the growing Wometco theater chain and restyled to include art deco features. Legions of youths and adults flocked to this neighborhood venue to view first-run movies. In 1960, as Cubans were flooding into the neighborhood, it became the first theater in Dade County to offer titles in Spanish. (Courtesy Arva Parks.)

With winds in excess of 130 miles per hour, the killer hurricane of September 17, 1926, brought death and destruction to Dade County. The flooding and destruction from the storm is evident in this image, which looks east from near the intersection of Twelfth Avenue and West Flagler Street. Worse conditions prevailed in other parts of the city and county. Until Hurricane Andrew struck the area in 1992, the hurricane of 1926 was considered "The Big One." (Courtesy Larry Wiggins.)

The ferocious hurricane of September 1926 damaged or destroyed thousands of homes. The home of Jacob and Ethel Straight at 1451 Northwest First Street was damaged by the storm. The high winds from the storm sent a beam from the house next door through the roof of the house. Soon water was pouring into it. The Straights patiently rebuilt their home. (Courtesy Dr. William Straight.)

Located in a beautiful Belvedere bungalow, Ahern Funeral Home opened its doors for the first time on West Flagler Street near Northwest Thirteenth Avenue in the 1920s. Later it became Ahern Plummer Funeral Home and still later Plummer Funeral Home, owned and operated by the politically powerful family of Joseph Plummer. Today St. John Bosco, a beautiful basilica-styled Roman Catholic church occupies the site. (Courtesy Larry Wiggins.)

This neoclassical structure standing on the northwest corner of Southwest Eleventh Street and Fourteen Avenue was the home of John Riley, the first mayor of Miami, and his wife, Marie. They wished to be near their daughter and grandchildren in the twilight years of their lives. Built in 1927, the home became SS. Peter and Paul Russian Orthodox Church in 1954. Located in the Shenandoah neighborhood, it has served a small but vibrant congregation since then. (Courtesy Arva Parks.)

Joseph Mero's Ta-Miami Motor Repair Company was located on Southwest Eighth Street near Sixth Avenue in the 1920s. Mero specialized in the repair of Wills St. Claire, Rickenbacker, Cadillac, and Buick automobiles. Joseph Mero is standing under a sign announcing the impending move of the business to a new location six blocks west on Southwest Eight Street near Thirteenth Avenue in 1927. (Courtesy Alba Mero Lingswiler.)

Alba Mero is seated on the top of a convertible in her father Joseph Mero's repair garage at 1261 Southwest Eighth Street in 1929. The 1920s marked the transition of Southwest Eighth Street, known earlier as Orange Glade Road, and later as Twentieth Street, from a dusty road used primarily by farmers to a major artery in a rapidly growing residential neighborhood. When the Tamiami Trail was completed through the Everglades in 1928, Southwest Eighth Street became its eastern link. (Courtesy Alba Mero Lingswiler.)

HIGH VIEW APARTMENT HOTEL 1325 W. FLAGLER ST. MIAMI, FLA. Y. C. FREED Owner

Portions of the City of Miami rest on a ridge that can reach 20 feet above sea level in some areas. Different parts of Little Havana stand on parts of the ridge. The High View Apartments, seen in this 1920s postcard, stood at 1325 West Flagler Street in a subdivision known as Riverside Heights. That block of West Flagler Street also hosted the Cushman Bakery, Ahearn Plummer Funeral Home, and Bascom's bird farm. (Courtesy Larry Wiggins.)

In the early 1900s, the eastern portions of Riverside and an area just south of it were host not only to black Bahamians but to whites, too. William "Tweedy" Sawyer, a fisherman from the Bahamas, arrived in Miami in the century's second decade and established the Standard Fish Company at 620 West Flagler Street in this building constructed with Dade County pine. Sawyer is pictured in the middle of this 1920s photograph. (Courtesy Mayra Beers.)

This is a seldom-seen photograph of Riverside Elementary School in 1927. Southwest Twelfth Avenue, formerly Lawrence Drive, runs in front of the school. The street had recently been widened and new sidewalks graced its edges. The original school was replaced at the outset of the 1970s by a series of uninspired, prefabricated buildings, which themselves gave way at the outset of the 1990s to the present building. (Courtesy Dr. William Straight.)

STATEMENT

IN ACCOUNT WITH

Victoria Hospital
925 N. W. 3rd Street
Miami, Florida

Dec. 24, 1942.

Mrs. Irene Stebbins
Rm. 43

HOSPITAL FEES PAYABLE IN ADVANCE																																																		PHONE 2-4123

PROFESSIONAL SERVICES RENDERED

Room: 12-21-42 to 12-24-42 4 days @ $6.00	$24.00
Delivery room	10.00
Nursery	4.00
Bracelet - baby	.50
	$ 38.50

```
              PAID      $50.00
              A/c        38.50
              Refund -  $11.50
```

Victoria Hospital opened in Riverside in 1924 at 925 Northwest Third Street. The neighborhood also hosted the smaller Riverside Hospital. Hospital charges in the early 1940s differed significantly from those of today, as evidenced by this statement, which billed the Stebbins family just $38.50 for the expenses surrounding the birth of baby Freddie. (Courtesy Fred Stebbins.)

The Ku Klux Klan entered Miami for the first time in 1921, heralding its arrival with a parade along downtown's Flagler Street. Soon after, the Klan was involved in kidnappings and floggings. In 1926, the Klan's John B. Gordon Chapter 24 moved into the new Riverside Mercantile Building at Southwest Eighth Avenue and Fourth Street, where this photograph was taken in the late 1920s. Posing as a law and order organization, the Klan maintained a visible presence in Miami well beyond the era of World War II. (From the author's collection.)

Among the early Jewish residents of Riverside were members of the Cowen family, who operated a successful downtown shoe business. Standing in front of the Cowen home at 2120 Southwest Sixth Street, are family friend Anna Kash (left) and Gertrude Cowen holding Myron Cowen. Raymond Cowen is the boy standing in front. Note the fashionable attire on display here. (Courtesy Melinda Cowen.)

Adorned in a military uniform complete with leggins, or cloth covering for the lower legs, is four-year-old Gladys Lavigne standing in front of her Riverside home in the late 1920s. Gladys's father owned and operated Donald S. Lavigne Uniforms, Inc., producing military uniforms for the armed forces. (Courtesy Melinda Cowen.)

Opened in 1928, Miami Senior High School was housed in one of the most beautiful school buildings in Florida. Designed by the famed architectural firm of Kiehnel and Elliott, the 13th century Norman–styled school includes a stunning auditorium on its western flank, as seen here. The auditorium, which underwent an extensive restoration at the end of the 1980s, still hosts a wide variety of events. Today the school is embarking on a $95-million restoration and expansion that will return the original buildings to their late 1920s splendor. (Courtesy Larry Wiggins.)

The city of Miami's extensive trolley car system included a line that rambled from downtown along Southwest Second Avenue, passing the carbarn at river's edge before crossing the bridge and turning west onto Sixth Street. From there, it proceeded west to Southwest Sixteenth Avenue before turning north to its terminus at Northwest Seventh Street. The line operated from the early 1920s until 1940. (Courtesy Historical Museum of Southern Florida.)

The iconic Firestone store and service station, which opened in the late 1920s, graced the southwest corner of the bustling intersection of Southwest Twelfth Avenue and West Flagler Street. The Riverside Firestone store was a special favorite of its owner, Harvey Firestone, and claimed as a visitor his friend Thomas Edison. Today the building hosts a Walgreen's store. The store is pictured in the early 1940s. (Courtesy Arva Parks.)

The Flagler Hotel at 637 West Flagler Street was Riverside's preeminent hostelry for many years following its opening in the mid-1920s. The hotel became an apartment and later a rooming house. The hostelry stood on the north side of early Miami's broadest street and boasted that every room was "an outside room." The hotel lobby and lounge featured rocking chairs arranged around a large central hearth. (Courtesy Larry Wiggins.)

Today a Hispanic Jehovah Witness church, this building at 1535 Southwest Third Street housed a Jewish Orthodox congregation, the first synagogue in the Riverside neighborhood, in the late 1920s. Later the Shaarei Zeddeck Congregation occupied the synagogue. The building is distinctive for its modified flying-buttress elements. (Courtesy Barbara Robbins.)

Four

DEPRESSION AND RECOVERY

Miami's fabled Orange Bowl was known from the late 1930s until 1950 as Roddy Burdine Stadium. It was named for the president of Burdine's Department Store, who died at age 51 in 1936. The stadium grew out of a New Year's day football game in 1934 held in Tatum Field, the site of the future Orange Bowl, in a makeshift "stadium," which utilized bleachers for spectators viewing a parade in downtown Miami the previous summer. The new Burdine Stadium began arising on the same site soon after the contest. The Orange Bowl has been the home of the Miami Dolphins, Super Bowl games, New Year's Day contests, and the University of Miami Hurricanes. This image is from early 1940s. (Courtesy Larry Wiggins.)

In 1936, the famed Dionne Quintuplets starred in *Reunion*, while a Carnation Milk promotion dominated the sidewalk in front of the Tower Theater. By then, the Tower Theater was part of the growing Wometco chain of theaters, and the art deco flourishes that had been added by architect Robert Law Weed are evident in the splendid marquee, steel casement windows, glass brick, and triangles near roof level. (Courtesy Arva Parks.)

Aurora (left) and Ideal Norantonio standing in front of their Shenandoah home at 1728 Southwest Twenty-first Street in 1937. The area had only recently been transformed from a wilderness to a residential neighborhood. Nearby was Sunshine Park, which periodically hosted the big tent of Ringling Brothers–Barnum and Bailey Circus. After the circus train unloaded its animal cargo on a siding of the Florida East Coast Railway near U.S. Highway 1 just east of Southwest Seventh Avenue, the animals would walk to the circus site. (Courtesy Ideal Gladstone.)

Standing across from the Orange Bowl on six acres of ridge overlooking the Miami River, Rivermont Park consisted of 30 rooms for patients desirous of "rest, convalescence and treatment." Operated by two physicians, the facility was part of a medical complex that included offices in New York. Today the Robert King High and the Haley Sofge Towers, subsidized elderly housing facilities, rest on a large portion of the Rivermont Park site. (Courtesy Larry Wiggins.)

Eleven-year-old Alba Mero is pictured next to the familiar Pepsi slogan of that era. The photograph was taken near her father's garage on Southwest Eighth Street near Thirteenth Avenue in 1939. (Courtesy Alba Mero Lingswiler.)

The Pinder girls are, from left to right, (first row) Eleanor, Shirley, and Ethel; (second row) Ida and Phyllis. They posed for this photograph on Easter Sunday 1936. The girls' forebears hailed from the Bahamas. They came to Miami from Key West in the 1930s and quickly became fixtures in their church, the Bible Truth Chapel, and in their new community. (Courtesy Mayra Beers.)

Jack Frohock and daughter Jacqueline are seated in their comfortable bungalow on Southwest Fourteenth Avenue near Third Street. Jack was a banker who also managed the family's large property holdings. (Courtesy Jackie Biggane.)

Joseph and Larry Mero stand on top of a Texaco gasoline truck in 1937 at the garage the former built in 1935 at 1277 Southwest Eighth Street just west of his previous facility. The image of the tire above the center window was molded out of concrete. In spite of the Great Depression, Joe Mero claimed a large, wealthy clientele. The building remained in the family until 1997. It is still standing. (Courtesy Alba Mero Lingswiler.)

Pioneer John Frohock was an early Miami city marshal and county sheriff. He was a frequent visitor to Riverside since his son and his family lived there in the 1930s and 1940s. The Frohocks were intensely interested in the history of their community, and John remained active in pioneer groups until his death in the 1950s. (Courtesy Jackie Biggane.)

Riverside was a neighborhood of well-kept homes and manicured lawns. Most of the homes were fashioned from Dade County pine, which was plentiful in the area. Typically, these homes included open porches enabling people to communicate easily with neighbors and passersby. What added to the attractiveness of the neighborhood was the human scale of its buildings. (Courtesy Jackie Biggane.)

These Riverside revelers prepare for Halloween night and trick or treat in 1936. Riverside youths also indulged in "Bum's Night," the evening before Halloween, when they roamed the neighborhood in a mischievous manner. (Courtesy Arva Parks.)

These Riverside residents pose for a Tom Thumb wedding at the nearby Tamiami Methodist Church in the 1940s. Both the Tamiami and Riverside Methodist Churches offered many activities for parish youths. Not surprisingly, many of the youngsters grew up together in the congregation and later married. (Courtesy Jackie Biggane.)

Organized in 1921, Riverside Baptist Church sat proudly at the corner of Southwest First Street and Ninth Avenue for more than 50 years. Sunday school classes gathered for this photograph, taken in 1931, on the eastern side of the original church. In 1959, the congregation wrapped a beautiful new church around this earlier building, but the church moved to Kendall in 1973, since few of its parishioners remained in the Hispanic neighborhood. (Courtesy Historical Museum of Southern Florida.)

Riverside was unusual in that many residential blocks were graced with "mom and pop" grocery stores. Pictured is the wood-frame structure at 1412 Southwest Third Street that housed Charles Zilowey's store, known simply as Charlie's Grocery. Charlie's opened for business in the 1920s and served the community for several decades. Today a Hispanic grocery store occupies the building. (Courtesy Jackie Biggane.)

Harvey's Restaurant
Established 1936
720 West Flagler Street
Miami, Florida

Established in 1936, Harvey's Restaurant was a favorite dining place for many of the business personnel in the Riverside neighborhood as well as for downtown workers. It remained in business till the end of the 1960s, as it, along with many other businesses and institutions in the area, became victims of changing demographics and tastes among the large Cuban population that moved into Riverside. (Courtesy Larry Wiggins.)

George Stebbins was an athletic legend at Miami Senior High School both for his physical prowess and for the fact that he played football without a helmet, as seen in photograph of him from a contest in the early 1930s. In the previous decade, the fearless Stebbins acquired the sobriquet "The Tivoli Kid" for his boxing skills, which were on display at the Tivoli Theater on West Flagler Street near Southwest Eight Avenue. (Courtesy Fred Stebbins.)

When the West Flagler Kennel Club opened in the early 1930s, Miamians could point with pride to another new tourist offering. The club stood at the edge of settlement at 3729 Northwest Seventh Street. Owned and operated by the Hecht family, the track drew large crowds each winter and offered big purses for special races. Today dog racing has lost much of its earlier popularity. The track now sits in a vast urbanized neighborhood, and more people come to its grounds for the weekend flea market than for any other reason. (Courtesy Larry Wiggins.)

Tropical Hobbyland was another Miccosukee village geared to the tourist trade of the early and middle decades of the 20th century. Located on Northwest Twenty-seventh Avenue and Fifteenth Street, Tropical Hobbyland claimed the only waterfall in south Florida. The attraction was also proud of its landscape and its year-round flower show. Miccosukees lived and performed on its grounds, as they did in other villages. (Courtesy Larry Wiggins.)

It was a city with few factories, but Miami could claim one that was sweeter than all others: Shenandoah Candies, which stood at 514 Southwest Twenty-second Avenue. The candy manufacturer's special offering was a coconut patty encased in chocolate. Opened for business in the early 1930s, Shenandoah Candies shipped its products to many parts of the United States. (Courtesy Larry Wiggins.)

The large, rambunctious Stebbins family lived in Grove Park, a beautiful subdivision developed by the Tatum brothers, in the early 1920s. Sitting on the south bank of the Miami River between Northwest Fourteenth and Seventeenth Avenues with Northwest Seventh Street on its southern perimeter, Grove Park was home to many of early Miami's leading citizens. The Stebbins siblings included three optometrists and one optician. From left to right are John, Freeman, George, Lawrence, Thomas Arthur Stebbins, and Bertrand Frederick Stebbins. (Courtesy Fred Stebbins.)

Standing ramrod straight in this mid-1930s photograph are Boy Scouts of Troop 12 at Holy Comforter Episcopal Church on the corner of Southwest First Street and Thirteenth Avenue. The group was preparing to attend a jamboree competition with other south Florida scout troops in Fort Myers. Troop 12 won the competition, excelling in events such as tent pitching, fire by friction, cooking, and flag signaling. The group's leader, William Straight, is on the far left. Straight became a prominent Miami physician who served as president of the Dade County Medical Association. (Courtesy Dr. Willaim Straight.)

The Flagler Street trolley is seen here on Flagler Terrace near Southwest Fourteenth Avenue in the late 1930s. The trolley was moving east toward downtown. Flagler Terrace converges with West Flagler Street at Southwest Twelfth Avenue. From there downtown is but a mile east. (Courtesy Historical Museum of Southern Florida.)

Bascom's Tropical Bird Haven at 1358 West Flagler Street was a popular attraction for visitors and residents alike in the middle of Riverside. The business featured flamingos and many other kinds of birds. It operated from the 1930s through the 1950s. (Courtesy Arva Parks.)

Bob Traurig is a name partner in the mega law firm Greenberg Traurig, LLP, and is recognized as one of the nation's finest environmental and land development attorneys. Traurig arrived in Miami from Connecticut as a boy during the Great Depression. In 1933, the Traurigs settled in the Riverside neighborhood, whose Jewish population was growing significantly. Bob attended schools in the neighborhood, including Miami Senior High School. (Courtesy Greenberg Traurig, LLP.)

75

WOODLAWN PARK MAUSOLEUM, WOODLAWN PARK CEMETERY, 32ND AVE. AND S.W. 8TH ST.

The beautiful neo-Gothic mausoleum in Woodlawn Park was built in stages, beginning in the late 1920s. It is the final resting place for members of the Brickell family and many other prominent Miamians. The cemetery also contains the remains of three presidents of Cuba and a Nicaraguan president, Anastasio Somoza. (Courtesy Larry Wiggins.)

TAMIAMI TOURIST COURT
CABINS AND 150 TRAILER SPACES
3038 S. W. 8TH ST., MIAMI FLA.

The Tamiami Trail offered a wide variety of accommodations for visitors, including the Tamiami Tourist Court with its cabins and vast trailer spaces. The trail was a busy road since it was part of Highway 41, the first road to cross the Everglades in 1928. (Courtesy Larry Wiggins.)

Visitors were always dazzled upon entering Musa Isle by its alligator pen, which was usually stocked with reptiles. Many purchased souvenir alligators upon leaving the attraction. (Courtesy Larry Wiggins.)

These precocious kindergarten students at Shenandoah Elementary School participated in a Christmas play in 1937, with Felicia Orovitz sweeping the cobwebs from a Christmas tree. Located at 1114 Southwest Twentieth Avenue, Shenandoah Elementary opened in the mid-1920s on a site that had been farmland until then. Until 1940, a junior high school by the same name stood one block south of it. (Courtesy Felicia Deutsch.)

Ruth and Max Orovitz are pictured in Shenandoah in 1936. Behind them stands a coconut palm tree. Shenandoah and much of Greater Miami were filled with coconut palm trees until thousands were felled by disease in the late 1970s. The Shenandoah neighborhood offered a tranquil ambiance amid beautiful Mediterranean Revival homes. (Courtesy Felicia Deutsch.)

Coral Way Elementary School, located at 1950 Southwest Thirteenth Avenue, was completed in 1936 by the Public Works Administration (PWA). An attractive school with New Deal–era murals, Coral Way is the nation's oldest 20th-century bilingual school. The institution began offering instruction in English and Spanish in 1963 in response to the surge of Cuban refugee families in the neighborhood. (Courtesy Coral Way Elementary School.)

SS. Peter and Paul Roman Catholic Church, the first Catholic church in Little Havana, celebrated its inaugural mass on Christmas Eve 1939 with only the roof beams overhead. With the church filled, a crowd of worshippers stood out in the street to hear mass. SS. Peter and Paul has been the parish for many prominent Miamians, including several Miami mayors. In 1980, Republican presidential candidate Ronald Reagan visited the church. (Courtesy Larry Wiggins.)

Two elements of a typical Miami home in the middle decades of the 20th century are seen in these two photographs taken in the late 1930s in the Shenandoah neighborhood: the ornate screen door and the picture window. In the first photograph is Felicia Orovitz, and in the second, along with her is her mother, Ruth, and brother, James. (Courtesy Felicia Deutsch.)

Gardner Mulloy is the city's most famous homegrown tennis star. A resident of Spring Garden, located just across the Miami River from Riverside/East Little Havana, Gardner Mulloy began playing tennis as a pre-teen in the 1920s. He spent the next several decades sharpening his tennis skills at Henderson Park, Greater Miami's foremost tennis facility, on Northwest Second Street and Ninth Street. Gardner Mulloy's triumphant career included a victory at Wimbledon in men's doubles at age 43 in 1957. This photograph is from the early 1990s. (Courtesy Gardner Mulloy.)

Five
WAR AND PEACE

The Miami Lighthouse for the Blind, known initially as the Florida Association of Workers for the Blind, represents one of the area's most beloved and important institutions. Founded in 1931, it received from the Lions Club 10 years later a small building at 601 Southwest Eighth Avenue, which is the nucleus for the current complex. This photograph was taken in 1941 at the time of the dedication of the new building. (Courtesy Miami Lighthouse for the Blind.)

The oldest Catholic school in Little Havana, SS. Peter and Paul opened its doors to its first students in 1941. The institution contained grades 1 through 12 during its first 15 years. Later it became an elementary and middle school. By the beginning of the 1960s, SS. Peter and Paul went to morning and afternoon shifts to accommodate the flood of Cuban refugees who arrived in the neighborhood. Many of the area's leaders matriculated at SS. Peter and Paul School. (From the author's collection.)

One of Miami oldest nursing homes, the Floridean Nursing and Rehabilitation Center at 47 Northwest Thirty-Second Place, opened in 1944. Named for its founder, Florence "Flori" Dean, a practicing nurse, the home has been owned and operated by four generations of the Dean/Rice family. When the institution opened in a building that had earlier housed the Sunshine Hospital, it was situated in a rural area just a few years away from a post–World War II development boom. (Courtesy the Floridean Nursing and Rehabilitation Center.)

Members of the nursing staff of the Floridean Rest Home, as it was known originally, are seen during a moment of leisure in the 1940s. The Floridean, which has invested in a high staff-patient ratio, is one of the longest-operating nursing homes in the area. (Courtesy the Floridean Nursing and Rehabilitation Center.)

85

Greater Miami was filled with men and women in uniform in World War II, as hundreds of thousands of servicemen came to the Magic City for training. Downtown Miami's waterfront buzzed with sailors training on PT boats. American, Chinese, and Soviet sailors, who were allied in World War II, trained together. Homes, churches, and U.S.O. chapters throughout the area took them in. Riverside's Bible Truth Church held Bible classes for sailors, including Chinese sailors, on Sundays. (Courtesy Mayra Beers.)

Dressed in her Easter finery in front of her Riverside home at 1367 Southwest Third Street is Arva Jean Moore, age four. Arva Moore Parks became an acclaimed chronicler of her hometown's history as an historian, author, and editor. Her early years spent in the warm confines of Riverside helped shape her calling as a historian. (Courtesy Arva Parks.)

Paul Tibbets Jr. (standing fourth from left with a pipe in his mouth) gained fame—and notoriety—for piloting a B-29 bomber carrying the first atomic bomb from the tiny Pacific island of Tinian to Hiroshima, where it was unleashed on August 6, 1945. Tibbets lived at 1716 Southwest Twelfth Avenue before enlisting in the Army Air Force in the early stages of World War II. Tibbetts named his B-29 for his mother, Enola Gay Tibbets. Enola Gay and her husband, Paul Tibbets, lived at 1629 Southwest Sixth Street in Riverside at the time of the bombing. (From the author's collection.)

The *Miami Herald* succinctly informed readers of the end of World War II with the headline, "War Ends." From left to right on August 15, 1945, are Shenandoah residents David, Donald, and Ronald Thompson. Donald Thompson was a longtime letter carrier and resident of Shenandoah. (Courtesy David Thompson.)

A Riverside/Little Havana landmark, Robert's Drugstore began operating in the 1920s at the corner of Northwest Seventh Avenue and West Flagler Street. Shortly after the end of World War II, the business moved to the southeast corner of Southwest Sixth Avenue and West Flagler Street, where it stands today. "Doc" Jerry Stern, a friendly, beloved pharmacist, operated the store for four decades until his death in the 1990s. (Courtesy Larry Wiggins.)

The Administration and Medical Building With Separate but Communicating Hotel Buildings

Main Lobby and Recreation Rooms

Sun Bathing Under Proper Supervision

The Sun-Ray Park Health Resort opened at 125 Southwest Thirtieth Court in the 1940s, when the area west of Northwest Twenty-seventh Avenue and north of West Flagler Street was a mix of piney woods and farmland. Spread over several acres, the health resort offered a spa for sun bathing, baths, massage, clinic, gymnasium and "complete sanitarium facilities" for the victims of various diseases. The institution stressed the curative value of ultraviolet sun radiation and retained on campus a physician, trained nurses, attendants, and a dietitian. (Courtesy Larry Wiggins.)

Robert Wolfarth was a Midwesterner who arrived in Miami in the 1930s and established the Cushman Bakery, which he named for Lucien Cushman, an attorney and friend whom he admired, at 1310 West Flagler Street in Riverside. Wolfarth later became mayor of the City of Miami. He, wife Mary, and their children lived in Shenandoah. (Courtesy Kathy and Bob Wolfarth.)

Cushman Bakery had several stores throughout the county, in addition to the Riverside store. The bakery's delivery trucks brought its products to the front doors of many homes. 1940s. (Courtesy Kathy and Bob Wolfarth.)

The author of this work spent his early years in Riverside at 1235 Southwest Fourth Street. In this November 1949 photograph, members of the George family stand with their house, a Belvedere bungalow, in the background. From left to right are (first row) Edward, Anna, and Paul George; (second row) parents Sargis and Alice George. Less than two years later, the Georges moved to another home with character one mile away in the Shenandoah neighborhood. (From the author's collection.)

One of the pleasures of living in beautiful Grove Park was, for many residents, the bustling Miami River as their backyard. Brothers David (in the foreground) and Freddie Stebbins behind him enjoy a boating outing on the stream near Northwest Sixteenth Street in the mid-1940s. (Courtesy Fred Stebbins.)

Ida Cohen, wife of Isidor Cohen, Miami's first Jewish settler, was the guiding force behind the creation of the Miami Jewish Home, as it was originally called. In the late 1930s, Adam Reiss, a retired businessman, informed his friend Ida Cohen that he wanted to donate $10,000 for a home for the Jewish aged. Under her leadership, the Jewish Home for the Aged was incorporated in July 1940 and opened five years later. (Courtesy Miami Jewish Home and Hospital for the Aged.)

The Miami Jewish Home and Hospital for the Aged, initially known as the Jewish Home for the Aged, was one of the area's most beloved and caring institutions and opened its doors in 1945 at the corner of Southwest Fourth Street and Twelfth Avenue. This photograph was taken at the official dedication of the home a couple of years after its opening. The institution remained in this Riverside location until 1951, when it moved to northeast Miami. It assists hundreds of elderly clients today. (Courtesy Miami Jewish Home and Hospital for the Aged.)

Six

The Postwar Boom

This late-1940s photograph indicates the liveliness of the intersection of Southwest Eighth Street and Fifteenth Avenue. Tower Theater patrons mill about. Across the street is the Ball and Chain Restaurant, Bar, and Package Store, which featured live entertainment. Entertainers included Cab Calloway and Billy Holiday, a rare happening for a neighborhood in a segregated Deep South city. To the right is a two-story building whose top floor was home to the Syrian-Lebanese Club. (Courtesy Arva Parks.)

Located near the busy intersection of West Flagler Street and Northwest Twelfth Avenue, Tyler's Restaurant was one of Riverside's most popular eateries and part of a chain by that name. Tyler's was a favorite venue for "power lunches" long before the term was coined. Much of the planning for the Baptist Hospital in the suburb of Kendall took place there. (Courtesy Larry Wiggins.)

A Riverside landmark in the mid-20th century, Jeff's Bar offered live entertainment centering around an attractive winding bar. Jeff's was accessed through an intriguing side entranceway into the Beramar Apartments building, which housed it. Its location was ideal since the intersection of West Flagler Street and Northwest/Southwest Twelfth Avenue was among the busiest and most important in Riverside. By the 1960s, it was out of business in a neighborhood increasingly comprised of Cuban refugees. (Courtesy Larry Wiggins.)

A landmark restaurant in Miami in the middle decades of the twentieth century was Mansene's Spaghetti House. Owned and operated by Nofry "Duke" Mansene, who was also its chef, the restaurant drew a large clientele from the West Flagler Dog Track across the street on Northwest Thirty-seventh Avenue. Mansene's was famous for its garlic sauce and advertised its pasta with the hyperbolic statement "We Sell It By The Mile." (Courtesy Larry Wiggins.)

The postwar building boom pushed Miami's boundaries far west. As the city and country grew, it became apparent that more cultural facilities were needed, prompting the completion in 1950 of the Dade County Auditorium at 29 West Flagler Street. This Streamline Moderne structure has hosted a rich array of events, including opera, graduations, awards ceremonies, concerts, Jewish worship services during the High Holy Days, and masses for nearby St. Michael the Archangel Roman Catholic Church. (Courtesy Larry Wiggins.)

Among the earliest post–World War II subdivisions were those that arose west of Northwest Twenty-seventh Avenue along the West Flagler Street corridor in what had previously been piney woods and farmland. St. Michael the Archangel Catholic Church was organized in 1947 to meet the growing need for a Roman Catholic church. A parish school opened in 1951. Its alumni include Gloria Estefan, the famed Cuban-American singer. This photograph of second-grade students dates from the 1973–1974 school year. (Courtesy Carlene Moragas.)

Nurses leave Victoria Hospital in this mid-century photograph. In the 1970s, a new building replaced the original hospital, but the institution closed in the early 1990s, as the neighborhood demographics changed dramatically, with the new arrivals going elsewhere for medical care. (Courtesy Dr. William Straight.)

WAGON WHEEL MOTEL
ON U. S. 41 "TAMIAMI TRAIL" MIAMI, FLORIDA

The Wagon Wheel Motel opened in the 1950s on the Tamiami Trail, one of scores of such hostelries built to accommodate the legion of visitors entering Miami from the west coast of Florida via this roadway. During the winter tourist season, many visitors stayed for extended periods in these motels. (Courtesy Larry Wiggins.)

Manon and Serge "Scrappy" Martinez were final grand-prize winners in an American Legion tap-dance contest in 1950. The brother and sister learned to dance at the popular studio of their aunt, Velma McKinley, at 819 Southwest Twenty-seventh Avenue and performed in different venues in Dade County. Serge Martinez went on to a successful career as a surgeon and attorney. Manon sang professionally as a teenager before turning her considerable talents to family and motherhood. (Courtesy Serge Martinez.)

Members of SS. Peter and Paul Mothers' Club pose proudly with Fr. Robert P. Brennan, the parish pastor, in the school cafeteria for this photograph taken in the mid-1950s. The organization was one of many lay groups that assisted in parish work. At the time of this photograph, a majority of the parishioners were Irish. Today an equally energetic parish is almost exclusively Hispanic. (From the author's collection.)

An integral part of SS. Peter and Paul School, which opened in 1941 and contained grades 1 through 12, was the band. In this mid-1950s photograph, members of the band are pictured with instruments on the stage of the auditorium, which doubled as a basketball gymnasium. William Krug, seen here, was its director. Several of his children played instruments. (From the author's collection.)

98

The Riverside neighborhood grew quickly after World War II. New apartments arose in many parts of the area. School enrollment soared. This mid-1950s Riverside class consisted of a mix of Deep South and Jewish students. By the latter part of the 1950s, a growing number of Spanish-speaking students were matriculating here. (Courtesy Richard De Aguero.)

Founded in 1955 at 666 Southwest Fourth Street in Riverside, the Hope Center, known initially as the Hope School for Mentally Retarded Children, is one of Little Havana's most important institutions, ministering to the needs of scores of mentally handicapped clients. Many live on its verdant grounds, which rest on a ridge on one of the most elevated portions of Little Havana. In this mid-1950s photograph, workers are pouring the foundation for another building in the rising complex. (Courtesy the Hope Center.)

Students received superb instruction from compassionate teachers at the Hope School, as it was known then, as indicated in these classroom scenes in the late 1950s. Many of the students remained as residents long after their formal schooling had ended. (Courtesy the Hope Center.)

As this photograph from the mid-1950s indicates, Ada Merritt Junior High School offered a splendid marching band and a vibrant cadre of majorettes. Practices took place on the grounds of Riverside Park (today's Jorge Mas Canosa Park), next to the school at Southwest Eighth Avenue and Third Street. Although the neighborhood was growing quickly, it differed dramatically from today with few automobiles, many vacant lots, towering Australian pines, and wood-frame bungalows dating to the early 1900s. (Courtesy Richard De Aguero.)

The county's oldest public junior school, Ada Merritt is named for a beloved pioneer educator and homesteader. Opened in 1923, the school, which rests on a ridge, was designed in the Spanish Colonial style. Many of Miami's future leaders matriculated there. (Courtesy Richard De Aguero.)

Luby Chevrolet was a successful Miami Chevrolet dealership in the mid-20th century. The company's showroom was located on the northeast corner of West Flagler Street and Eleventh Avenue. The Spanish Mission–style building housing the business was built in the 1920s and had served as the home of Hill Motor Company. By the beginning of the 1960s, Luby had moved to a new suburban location. (Courtesy Arva Parks.)

William Singer opened his first Royal Castle in the Little River neighborhood of northeast Miami in the late 1930s. By the 1950s, the Royal Castle chain had grown to include scores of little restaurants with their trademark hamburgers, birch beers, and fresh-squeezed orange juice. Riverside and Shenandoah hosted Royal Castles. (Courtesy Jewish Museum of Florida.)

In the late 1920s, Miami's small Greek community organized Saint Sophia Church near downtown Miami. Twenty years later, the growing congregation built a beautiful house of worship at 2401 Southwest Third Avenue (Coral Way) in the Roads neighborhood, which attracted worshippers from many parts of southeast Florida. The congregation remains robust thanks in large measure to the strong leadership of the late Fr. Demosthenes Mekras, its spiritual leader for much of the postwar era. (Courtesy Thespo George Portafekas.)

The junior choir of Riverside Methodist Church prepares to enter the sanctuary of the building in 1956. The congregation provided many outlets for its members, including numerous youth activities and organizations. Many of those pictured here remained members of Riverside until recent years. (Courtesy Marilynn Hallman.)

103

Carl Weinkle was another enterprising Jewish businessman who owned a chain of liquor and grocery stores. The latter were known as Carl's Market. A Carl's Market operated at Southwest Eighth Street and Nineteenth Avenue in Riverside in the late 1940s and early 1950s before it was acquired by the Food Fair supermarket chain and its name changed. (Courtesy Jewish Museum of Florida.)

Samuel Friedland was a fabulously successful businessman who counted among his holdings the Diplomat Hotel in Hallandale Beach and a large chain of Food Fair supermarkets. By the 1960s, Food Fairs operated on Southwest Eighth Street and Nineteenth Avenue as well as on Coral Way near Twenty-first Avenue. The stores were patronized by a large Jewish clientele. (Courtesy Jewish Museum of Florida.)

104

By the 1950s, Shenandoah and Riverside contained four synagogues. One of the largest and oldest was Temple Beth El at 500 Southwest Seventeenth Avenue. In this photograph from the early 1950s, several of its younger members are shown holding awards they received for different achievements. The temple remained at this location into the 1970s, long after most of the Jewish population had left the neighborhood. (Courtesy Jewish Museum of Florida.)

Temple Beth El's Sisterhood, a strong supporter of the congregation, raised money and enlisted many of its members in different causes in behalf of the congregation. Sisterhood women are shown here in the early 1950s staging a play, one of many presentations the group was responsible for over the years. (Courtesy Jewish Museum of Florida.)

105

Founded in 1912 as B'nai Zion, Beth David was Miami's first synagogue. The growing congregation moved into its first house of worship in downtown Miami in 1920. Nearly 30 years later, it moved into this handsome structure designed by Charles Neider on Coral Way and Southwest Twenty-sixth Road. At the time of its opening, the synagogue was the largest Jewish house of worship in Florida. (Courtesy Jewish Museum of Florida.)

Pictured here in an early 1950s photograph are members of the choir of Beth David Congregation. For nearly 100 years, the congregation has maintained a proud tradition of lay participation in virtually all of its offerings. (Courtesy Jewish Museum of Florida.)

In the years immediately following World War II, the Miami Jewish Congregation opened its doors to the neighborhood at 1101 Southwest Twelfth Avenue. Over the years the congregation's name changed, becoming the Miami Hebrew School and Junior Congregation and later the Beth Kodesh Synagogue until the late 1980s. Today a Hispanic Baptist church occupies the building. A cross stands above the entranceway and over the Star of David, which underlines the great changes in the neighborhood. (Courtesy Barbara Robbins.)

For Jewish youths of Riverside, the Young Men's Hebrew Association, at 1567 Southwest Fifth Street, was a popular venue. An art deco structure erected in the late 1930s, it offered an indoor basketball court and an outdoor area for a variety of activities. By the 1970s, the one-time Jewish neighborhood was overwhelmingly Hispanic. At that point, the building became the home of the José Martí International Youth Center. Today it houses a private school. (Courtesy Jewish Museum of Florida.)

Miami was a multicultural city long before that term became popular. The Roads neighborhood, in the aftermath of World War II, attracted many different nationalities, including Jews, Italians, Greeks, Syrian, Lebanese, and Irish. One of the most popular venues for Middle Easterners living both within and outside of the neighborhood was the Syria-Lebanese Club built by Sam Joseph and Alex Jepeway on Coral Way in the Roads. The founding directors of the club are seen in this 1950s photograph. (Courtesy Shirley Maroon, Ron Israel, and Jean Karaty.)

The family of A. W. Gort migrated to Miami from Cuba in 1954 and opened Gort Studios on Southwest Eighth Street near Sixteenth Avenue. The family has contributed significantly to the business and civic culture of Miami. A. W.'s son, Willy, was a long-serving City of Miami commissioner. A portion of today' Southwest Sixteenth Avenue is named for A. W. Gort, seen in this photograph in 2000. (Courtesy the Gort family.)

Seven
Little Havana

The area's premier athletic high school football power from the 1920s through the mid-1960s, the Miami Senior High School Stingarees won countless conference and state titles. The 1960 edition, seen here, won the national championship after a rousing come-from-behind victory over a powerful team from Brockton, Massachusetts. Five years later, the Stingarees won another national championship. (Courtesy David Thompson.)

On December 29, 1962, Pres. John F. Kennedy and wife Jacqueline were escorted by Miami mayor Robert King High after their helicopter landed near the Orange Bowl. Before thousands of people in the Orange Bowl, the president met members of the Assault Brigade 2506, many of whom had only recently been released from Cuban prisons after the unsuccessful attempt to topple Fidel Castro at the Bay of Pigs. The brigade presented a Cuban flag to Kennedy, who assured them that it would "be returned to this brigade in a free Havana." Eleven months later, the young president was slain. (Courtesy Historical Museum of Southern Florida.)

Allah's Garden Restaurant opened in the 1920s on the Riverside edge of the busy Tamiami Trail. In 1965, Centro Vasco opened there. Owned by Juan Saizarbitoria, the restaurant was named for a popular pre-revolution restaurant in Havana. Little Havana's Centro Vasco became a popular venue for the city's growing Cuban-American population, especially its business, political, and artistic leaders. It closed after it was subjected to boycotts, protests, and intimidation upon booking a Cuban singer who had not yet repudiated Fidel Castro. (Courtesy Larry Wiggins.)

Felipe Valls Sr. opened Badias Restaurant in 1965. Badias operated from the 1960s till the beginning of the 1980s, providing many Americans with their first taste of Cuban cuisine and larger numbers of Cubans with tasty, low-priced fare. For many people journeying to Miami's Orange Bowl, Badias was a favorite stop for dinner or a Cuban sandwich. Today El Pub, another landmark Cuban restaurant, occupies this space on the southeast corner of Southwest Eighth Street and Sixteenth Avenue. (Courtesy Larry Wiggins.)

Greater Miami's most famous Cuban restaurant is the Versailles, located in the 3500 block of Southwest Eighth Street. Opened in 1971 by Felipe Valls Sr., the restaurant was named for an eatery by that name in Santiago, Cuba. The expansive restaurant, with 350 seats, includes a Hall of Mirrors dining room. It remains a favorite venue for visiting politicians, from U.S. presidents to local officeholders. (Courtesy Larry Wiggins.)

A *tabaquero*, or cigar roller, works at El Credito, one of the largest handrolled cigar factories in Miami–Dade County. Founded by the Carillo family in Havana in 1907, the business was reconstituted by the same family in Miami in 1969. The factory spreads over several storefronts in the 1100 block of Calle Ocho. It also claims plants elsewhere in the county and in the Dominican Republic. It customers have included Robert Goulet, Bill Cosby, and Arnold Schwarzenegger. (Courtesy Barbara Robbins.)

Cuban refugees rally at Miami City Hall in April 1980 in support of many their brethren in Cuba who had taken refuge in the Peruvian embassy with the hopes of migrating to the United States. Within one week of this protest, the Mariel Boatlift was underway, changing forever Miami and Dade County as more than 125,000 refugees poured into the county in a six-month period. (Courtesy Historical Museum of Southern Florida.)

Tent City was a makeshift encampment for hundreds of homeless Cuban refugees who came to Miami in the Mariel Boatlift in 1980. The United States government created the camp after learning that Mariel refugees living in temporary quarters in the Orange Bowl would have to vacate it with the onset of football season. Located under I-95 near Southwest Fourth Street and Fourth Avenue, the camp operated from July until the fall of 1980. (Courtesy Historical Museum of Southern Florida.)

Food purveyors are familiar sights on Calle Ocho during parades, demonstrations, and other events on this bustling street. In the side streets off of Calle Ocho, produce vendors in open trucks sell vegetables and fruits to neighborhood residents. This photograph shows Calle Ocho in the 1980s. (Courtesy Barbara Robbins.)

The 24th anniversary of the Bay of Pigs campaign was observed by these veterans of Assault Brigade 2506 in 1985. They were photographed while standing at attention in front of the memorial to their compatriots who lost their lives in the invasion. The failed attempt to overthrow Fidel Castro is seared in the memory of Cubans. (Courtesy Historical Museum of Southern Florida.)

Standing at the eastern edge of Little Havana, José Martí Park is a small greensward named for the apostle of Cuban independence, whose bust resides in the southern portion of the facility. Opened in 1985, this five-acre park has hosted Cuban Independence Day celebrations and a host of other events. It looks out over the busy Miami River in this 1986 photograph. (Courtesy Historical Museum of Southern Florida.)

By the early 1960s, the backyards of many homes in the old Riverside and Shenandoah neighborhoods were scenes of intense activity on the day before Christmas, as Cubans roasted pigs for the traditional Noche Buena or Christmas Eve dinner. The aroma of roasted pigs wafts through Little Havana on this special day in the mid-1980s. (Courtesy Historical Museum of Southern Florida.)

The Torch of Freedom stands in the median of Cuban Memorial Boulevard in front of Casa Del Preso, a home occupied by former Cuban political prisoners. When a prisoner is freed and arrives in Miami, he is often welcomed with a ceremony by the torch. The monument was created in the mid-1980s and stood for many years in Jorge Mas Canosa Park before it was moved in the 1990s to its present location. (Courtesy Barbara Robbins.)

Pres. Ronald Reagan appeared in Little Havana on Cuban Independence Day, May 20, 1983. Widely popular among Cuban-Americans because of his fierce anti-Communism, the president received a warm welcome and a wonderful meal of chicken, rice, and beans, plantains, flan, and café Cubano at La Esquina De Tejas, a popular restaurant at 1201 Southwest Twelfth Avenue. (Courtesy Lian and Alex Chamizo.)

El Exquisito Restaurant, at 15 Southwest Eighth Street, is a Little Havana favorite that serves oversized Cuban sandwiches and heaping meals to Cubans and non-Cubans alike. At the little window, large numbers drink cups of sweet café Cubano. Others, upon alighting from a presentation or movie in the Tower Theater next door, visit El Exquisito for a late snack. (Courtesy Barbara Robbins.)

Demonstrators and protestors shout remarks to patrons exiting the Cuban Art Museum at 1300 Southwest Twelfth Avenue. They were protesting the presence of works by Cuban artists in July 1988. The beleaguered museum suffered worse when it was dynamited as part of this lingering protest. It closed soon thereafter. (Courtesy Historical Museum of Southern Florida.)

This bust of Manolo Fernandez is a recent addition to the monuments gracing the center of Cuban Memorial Boulevard near the northern edge of La Rambla, a winding walkway stretching along the entire 1.3-mile-long boulevard. Fernandez was known as the "King of the Tango" in Cuba and was also a renowned actor. He died in Miami in 2001. (Courtesy Barbara Robbins.)

"Cafeterías" are staple items of Little Havana where people, especially men, gather outside to drink café Cubano, smoke cigars, and discuss conditions and affairs, often with passion, in their former island home. (Courtesy Barbara Robbins.)

Celia Cruz, a beloved chanteuse among Cuban exiles, died in July 2003. Her death was the occasion for an outpouring of grief extending over several days. After her body was flown to Miami, there was a public viewing attended by thousands at the Miami News Freedom Tower. Then mourners attended a solemn mass at Gesu Catholic Church in downtown Miami. (Courtesy Barbara Robbins.)

At the head of Cuban Memorial Boulevard stands the famed memorial torch that burns for the memory of the 107 men who lost their lives in the ill-fated Bay of Pigs campaign against the forces of Fidel Castro in April 1961. The torch was placed in Cuban Memorial Plaza in 1971 and has served as a gathering place for demonstrations, observances, and remembrances since then. (Courtesy Barbara Robbins.)

Domino Park is one of Little Havana's favorite spots. Here men—and a few women—of retirement age and beyond enjoy endless games of dominoes, chess, and cards. The park began as an informal affair in the early 1960s before becoming a city facility. It is open daily, drawing scores of participants and even more visitors. For its regulars, Domino Park is an abiding passion. While it is formally known as Maximo Gomez Park for a Dominican general whose bust in appears in the second photograph and who assisted Cuba in its war of independence with Spain in the 1890s, everyone knows it simply as Domino Park. (Courtesy Barbara Robbins.)

One of the most popular activities in Little Havana each January is the Three Kings Parade held in observance of the Feast of the Epiphany, when the three wise men visited the Christ child bearing gifts. The parade, seen here in the 1980s, courses along Calle Ocho for a few miles. It has been held annually since 1971, the year Fidel Castro forbade the celebration, drawing large crowds for each edition of it. (Courtesy Barbara Robbins.)

In this 1987 photograph, Moises Bonet repairs the arm of San Lázaro, revered Cuban saint of the poor and the Miracle Worker. Many *botánicas* throughout Little Havana sell statues of San Lázaro and other Cuban saints. In the early years and decades of the Cuban exile presence in Little Havana, many residents placed statues of San Lázaro in their front yards. (Courtesy Historical Museum of Southern Florida.)

Little Havana contains many storefront cigar factories and stores. Skilled *tabaqueros*, employing only rudimentary tools, fashion these cigars. These men are enjoying a smoke and a conversation from the comfort of a sofa in a store along Calle Ocho. Many of these stores have large shipment orders as well as walk-in business. (Courtesy Barbara Robbins.)

Botánicas are stores stocked with statues, incense, oils, candles, and, in some cases, live animals. All of these elements are used by *santeros* in the Santería observance. Santería is an Afro-Caribbean religion popular in the Cuban and Haitian communities. Its practice has engendered controversy since many of its members practice animal sacrifice. (Courtesy Barbara Robbins.)

Little Havana began to change for the better in the mid-1980s, after the heart of it was declared "The Latin Quarter," and many infrastructure improvements were introduced. By the 1990s, many people with an interest in the quarter began to invite artists, lured by reasonable rents, to open studios and galleries. Held on the last Friday of each month, *Viernes Culturales* or Cultural Friday showcases along Calle Ocho the works of many area artists. (Courtesy Viernes Culturales.)

The close ties between Havana and Miami, two blockbuster tourist cities, was underlined in 1957 when representatives of the Cuban government presented this statue of the Blessed Mother and the Christ Child to Miami as a token of friendship. People are attracted daily to the statue standing in the middle of Cuban Memorial Boulevard, and many pray before it. On Mothers Day, a group of Hispanic women sing spiritual songs to the Blessed Mother. (Courtesy Barbara Robbins.)

The most famous home in Little Havana stands at 2319 Northwest Second Street. For five months in late 1999–2000, it was the home of Elian Gonzalez, the young Cuban boy whose fate became a huge, international story. It was there that Elian was taken by federal marshals and INS officials in April 2000 in a dawn raid. Today the home is owned by the family and is operated as a museum of Elian. (Courtesy Barbara Robbins.)

The annual feast of *la Gritería* (the Shouting) is celebrated throughout Little Havana by the large resident Nicaraguan community annually on the evening of December 7, which heralds the Catholic feast of the Immaculate Conception. Groups of Nicaraguans will journey from altar to altar, upon which the Virgin stands surrounded by flowers and bathed in lights in front of homes and businesses. At each stop they dance and sing songs to the Virgin Mary. This photograph shows *la Gritería* in 2005. (From the author's collection.)

The beautiful home of Jorge and Soledad Cano was the venue for a Spike Lee commercial video for State Farm Insurance around 2000. Spike Lee is standing near the doorway. Built in 1937, the home is a glorious Colonial Revival building and one of several stunning 1930s homes gracing both sides of Southwest Twelfth Street between Fourteenth and Sixteenth Avenue. (Courtesy Jorge and Soledad Cano.)

The Calle Ocho Open House, held the second Sunday in March since 1978, is billed as the "world's largest outdoor Hispanic festival" with an estimated one million revelers joining in the daylong spectacle. The festival, which stretches for two miles along Calle Ocho, features vendors of many kinds, singers and bands, retailers handing out free samples, and impromptu conga line dancers who fill the street with a party scene unlike anything seen elsewhere. Sponsored by the Kiwanis Club of Little Havana, the event draws visitors from the Caribbean and Latin America. It marks the culmination of the eight-day Lenten-related Carnival. (Courtesy Kiwanis Club of Little Havana.)

Calle Ocho is many things to Miami's large Cuban exile community, including a venue for political protest usually related to issues, personalities, and events in the homeland. In April 1976, a large protest march on Southwest Eighth Street near Sixteenth Avenue centered on the treatment of political prisoners on the island. (Courtesy Historical Museum of Southern Florida.)

ACROSS AMERICA, PEOPLE ARE DISCOVERING
SOMETHING WONDERFUL. *THEIR HERITAGE.*

Arcadia Publishing is the leading local history publisher in the United States. With more than 3,000 titles in print and hundreds of new titles released every year, Arcadia has extensive specialized experience chronicling the history of communities and celebrating America's hidden stories, bringing to life the people, places, and events from the past. To discover the history of other communities across the nation, please visit:

www.arcadiapublishing.com

Customized search tools allow you to find regional history books about the town where you grew up, the cities where your friends and family live, the town where your parents met, or even that retirement spot you've been dreaming about.